T0072298

The Artist's Virtues

A Guide for Getting Started and
Continuing to Grow as an Artist

Kathleen Broaderick

BALBOA.PRESS

A DIVISION OF HAY HOUSE

Balboa Press books may be ordered through booksellers or by contacting:

Balboa Press
A Division of Hay House
1663 Liberty Drive
Bloomington, IN 47403
www.balboapress.com
844-682-1282

Print information available on the last page.

ISBN: 979-8-7652-4223-0 (sc)
ISBN: 979-8-7652-4224-7 (e)

Balboa Press rev. date: 08/17/2023

This book was written with love, to give you inspiration and practical steps to start now and to continue to grow as an artist throughout your life. Since painting is my medium, I write with painters in mind, but you can follow this path in exploring any area of art.

Contents

Preface .. ix

Introduction .. xi

Chapter 1 My Journey 1
Chapter 2 The Aspiring Artist 8
Chapter 3 The Elemental Artist 18
Chapter 4 The Seeing Artist 30
Chapter 5 The Intuitive Artist 40
Chapter 6 Personifying the Virtues 49

Glossary of the artist's virtues 55

Preface

I didn't go to art school. I went to elementary school. *Twice.* Once when I was a child and then again in my late forties.

The second time, I taught children in kindergarten through fifth grade about art—real art! I introduced my classes to lines, shapes, and colors, and to Matisse, Monet, and the *Mona Lisa*. Their curiosity and joy for art was overwhelming. And I found the teacher within.

As a hobby artist since my twenties, I had heard much of what I was teaching my students from various instructors and classes over the years. But now, as I focused on how best to teach it to my neophyte artists, the basic concepts of art returned front and center in my mind. I soon noticed my own artwork getting better and my sales growing.

I didn't realize it then, but as I look back, the key to my success in fine art was going back to elementary school and rediscovering the basic elements of art.

Introduction

There is a reverence for what an artist does—creating what seems magical and mysterious. It can feel magical too. Magical moments can come from a harmony of technical skills and virtues of the artist.

You may be saying, "Yes, please, I'd like that magic." Or you may have a desire for the solace that creative activities can bring to your life:

- the *personal growth* gained by learning, growing, and working at your craft
- *relaxation* by thinking and doing something totally different from day-to-day life
- *calm* from the storm
- *peace* of mind
- the *pleasure* of dipping your paintbrush into ooey-gooey paint and making marks on the canvas

- the *joy* of creating
- the *fulfillment* of making something you (and others) love
- the *excitement* of discovery
- the *self-discovery* of what you can *do*
- the *self-expression* of what you can *make*
- the *self-satisfaction* of being able to say, "I made that"
- the *happiness* of making something beautiful
- the *love* of making and giving
- the *escape* from the usual routine
- the *fun* of playing
- the *challenge* of learning something new
- the *beauty* of creation
- the *freedom and flow* of expression
- the feeling of *inspiration*
- the *wonder* of the natural world
- the *confidence* in yourself and your painting process
- a *quest* for a more-than-ordinary existence
- and perhaps even *selling, showing,* or *teaching*

If this is you, you *do* have the capacity to make beautiful things.

It is not magic. There is a path you can follow that will lead to your unique artistic expression. It starts with learning an artistic language and basic skills.

You are now on the path. You have found the book of someone who's already begun.

Chapter 1

My Journey

In looking at my own journey as an artist, I've distinguished four stages – aspiring, elemental, seeing, and intuitive. Here is a brief synopsis of my journey through each.

The enthusiasm for painting hit me in 1986, when I was twenty-one years old. I was in New York for my cousin's wedding and visited the Metropolitan Museum of Art. There I saw an intriguing watercolor painting, Prendergast's *Umbrellas in the Rain*. Oh, all the beautiful shapes of color! Looking at it just made me happy—so happy that I bought the poster in the gift shop and put it up in my room for my senior year of college.

When I was choosing my last-semester classes, I realized after scheduling my required classes that I

needed one last credit to fill my schedule. I chose a watercolor class. It was a little scary for me, but the excitement of possibly making something like my Prendergast painting was calling me.

I became an aspiring artist.

The experience of putting paint down on the paper just felt right. It connected to something deep inside. I was beginning to learn. Many years lay ahead, but this was the start of my lifelong study of art.

My Elemental Artist

After college I worked in traditional jobs but was committed to taking art classes here and there. Life brought me to live in England, Chicago, South Florida, and then to North Florida. Art was just something fun I did as a stay-at-home mom when I had the time. I never imagined it as a career.

Things changed when my oldest son was getting ready to go off to college. I took him to his orientation weekend and saw an inspiring speaker who left me with an interesting question: "What gift do you have inside that you could share with the world?" Hmm. I liked art. I liked kids. *I will become an art teacher,* I thought, *and share art with my students.*

Long story short, I did just that. Within two years, I became Edge Elementary School's first ever art teacher. I discovered I loved teaching, and the students loved to learn about art. It was through my research on how best to teach them about art that I rediscovered the basic elements of art. Through teaching my students, these simple yet powerful rules of art found their way into my own original artwork, though I did not realize this until later. I started to become a better painter, and sales flourished. It was an exciting time of self-growth. I learned I was a much better student now than I was in college, and I felt I could learn anything. I had a new idea.

Could I learn to become a better artist and take this passion to a new level?

I stopped teaching and started to focus on my artwork. The morning ritual included getting up early and painting. I knew it would take lots of practice. I also did lots of research, searching online for artists I liked and hoping they had a demo showing how they made their magic. I studied up in areas I was not good at, like color. I set a goal to create my own website within six months. I soon started showing at local shows and a local gallery.

My Seeing Artist

I was still not putting my progress together with why I was getting better, but I was diligent about making it work. I started having moments of enlightenment that told me I was on the right track.

One day I was painting a flower that had a petal with a flipped-over edge. I knew this was a very important thing to get right in the painting. *What are the individual shapes that make up the petal?* I thought. I painted the shapes one by one, carefully looking at how each related to the other. I took a break and left the studio for lunch.

When I returned, I saw my painting from afar and gasped. There was the flower with the amazing flipped-over petal, and it looked good! It looked like it was supposed to. I was amazed that I had done this. Had someone snuck in and painted this while I was away? The realization hit: by just concentrating on the shapes, I had painted the flower.

Painting wasn't magic. I was starting to become very aware of the power of the elements. When it came time to create my basics of painting course, *Essential Elements,* I started analyzing my painting process and had the big ah-ha moment. It was the elements of art that I had been teaching my

elementary students that had been guiding me these past few years in my fine art, helping me grow and get better. Suddenly I knew the key. This was exactly what I had to teach my adult students who wanted to learn to paint.

My Intuitive Artist

I opened my studio, CHROMA, in Santa Rosa Beach, Florida, in 2017. I was going to the studio and painting almost daily. All the practice was paying off.

One day I realized I didn't have to think about what paint colors to mix together anymore. I just did it—quickly, too. I was confident in my process. I did not worry about the outcome as much because I focused on each step. And when I ran into something that I felt didn't look or feel right, the elements helped me figure it out and adjust my painting.

I also didn't worry about what my painting looked like to anyone watching me. Patience in the process meant knowing it may look "a mess," but also knowing that working the entire painting in this unfinished state was the best way to get the outcome I desired.

I continue to be excited to research, learn, and evolve as a person and painter, and I am so grateful to be able to share all that I learn.

The Evolving Artist: Aspiring, Elemental, Seeing & Intuitive

In charting this journey, I've come up with virtues that embody each stage we go through – aspiring, elemental, seeing & intuitive. My hope is that in reading through these you will recognize yourself and be encouraged to continue, knowing that you can learn and grow as an artist. This is not a strict "must-do" list but simply some things that I've seen work and that may be useful for you in your own art self-education. Whether you go to art school or elementary school, you are the one who must become the artist. No one can do it for you, but I would like to help by showing you a path.

Here's what's ahead:
- the four stages of artist growth
- the virtues of each stage
- a growth plan to progress to the next stage

The Aspiring Artist

The aspiring artist's symbol:
the awakening seed

*Many seeds are able to endure long periods of
drought, heat, or freezing temperatures, yet are
ready to spring to life when
favorable conditions arise.*

Mary Beth Bennet

In the aspiring artist phase, the artist within us
all may be dormant. We need to set favorable
conditions for that ability to sprout forth.

The Aspiring Artist's Virtues

Here are some virtues of an aspiring artist. You may find yourself saying, "Yes, I am feeling that way!" Keep going and nurture these virtues.

- **enthusiasm** - a strong excitement about something; a strong feeling of active interest in something that you like or enjoy
- **courage** - the ability to do something that you know is difficult
- **patience** - the ability to give attention to something

Enthusiasm

The aspiring artist feels a strong tug toward creativity and a strong interest to pursue this passion. Enthusiasm is a critical trait for establishing the discipline for what's ahead. You are full of potential energy—the seed waiting to burst into motion.

Courage

As an aspiring artist, you may not have much art experience, but your desire to create is strong.

Maybe you loved art in school but haven't created in years. You know the feeling of wanting to express yourself even though you're not fully aware of where to start. You have the courage to ask for and seek guidance. Many have gone before you in their quest to paint. At this stage, you may need someone to believe you can do it until you have the confidence to believe in yourself.

Patience

An aspiring artist might be busy with a job and family. Since time is limited and precious, consider how much time you have to dedicate to art. It doesn't matter how much time you have, as long as you're realistic about it. That way you won't feel guilty about not putting in the time you think you need to right now.

If you don't have a lot of time right now, you may think it's not even worth starting. If this is you, don't wait. Start now! I was a hobby artist for decades before I had more time to focus fully. One day your focus may change, freeing up time for creative expression, and with all your knowledge patiently stored over the years, you will spring into action with great enthusiasm.

Be not afraid of growing slowly,
be afraid only of standing still.
Chinese proverb

Watch Out for Fear

I've seen people come into my studio for a painting class too scared to put down a brushstroke. Fear can keep you tentative. It can even keep you from starting. Turn your fear around. What if you never started? What if you went your whole life without expressing the beauty inside you? You will start when the fear of not starting is greater than the fear of starting.

The Aspiring Artist's Growth Plan

Look for a teacher or mentor to help develop your natural abilities.

Learn from the successes and failures of other artists. If you do not feel like you are understanding in one class, move on to another. It may not be you; it may be the teacher. This could be a beginning art class at a local art center or an artist's studio. Online art classes are great options available to you to watch

on your schedule. Look for a teacher whose work you love and a class that will teach you the basics of art.

Search for inspiring artists to follow on social media, and save the images that grab your attention.

Whenever I see a social media post that grabs my attention, I save it. Some platforms like Instagram will then allow me to scroll through all my saved posts. I can then start to notice a theme in my "likes." It could be the same beautiful color that keeps attracting my attention or a new combination of colors I had not thought of. I might notice a theme in subject matter, that I am leaning towards floral paintings right now. This is gold! It is telling me what I am inspired about at the moment. I can use the information to kindle my creative fire and get to work.

Go to museums.

Find your favorites from the master painters of the past. There's nothing like gazing at Monet's *Water Lily Pond* from two feet away. But if you can't make it in person, check out museum websites. The

Louvre in Paris, France, for example, has virtual tours on their website.

Start an inspiration board.

An inspiration board is a collection of things you like. This can be a fun, tactile exercise done by cutting photos from magazines and pasting them on poster board to get a visual display of your creative leanings at any one moment. It can also be an online experience with search engines like Pinterest that makes it very easy to create an online board of favorite online things – paintings you like, colors, inspirational quotes, or decor. The idea is to notice a similarity or trend in your interests that will help you know where to focus your creative energy.

Start an art journal.

Any notebook will do. Fill it with art notes, doodling, and quick drawing exercises. These types of journals often become sources of inspiration for future projects

Visit local art shows for inspiration.

I always come home inspired to paint after visiting my local art shows. I love talking about art with the other artists and always find inspiration being surrounded by all of the art.

Practice with any paints you have at home, just for fun.

Enjoy the experience of mixing and painting on paper, canvas, or repurposed surfaces like pieces of scrap wood. Add lines, shapes, numbers, words, or symbols. Turn it into a mixed media piece by adding bits of collage like torn paper, glue, sand, glitter, or any found objects. "Just for fun" is key at this stage.

Try a local "paint and sip" class.

These are group classes that last a couple of hours where you can show up, be given all your art supplies and guided through creating a painting. The "sip" part generally refers to enjoying a beverage of your choice while you paint. The host may provide drinks and even food or allow you to bring your own. The classes usually do not have enough time

for much painting instruction but will allow you to enjoy the experience of making art.

Watch free online painting demonstrations.

You can just watch or paint along with the instructor on sites such as YouTube. If you search something like *painting basics for artists* you'll get hundreds of videos. Honestly, it can also be a little overwhelming. Narrow things down by gravitating to an instructor who is presenting easy-to-follow art basics or whose style you like.

Have patience with yourself.

Dedication to art studies is a lifelong journey.

The heart of an Aspiring Artist

1. The aspiring artist courageously steps forward and says, "Yes, I am going to do this!"
2. It feels a little scary, but exciting.
3. There's something bubbling inside that needs to get out.
4. You search enthusiastically for the best way.

Chapter 3

The Elemental Artist

The elemental artist's symbol:
the emerging sprout

From a small seed a mighty tree may grow
Aeschylus

When a seed falls on the ground, it needs warmth, water, and light in order to germinate.

This stage is about cultivating the structure and direction that the elemental artist needs in order to grow.

The Elemental Artist's Virtues

Here are some virtues of an elemental artist. You may find yourself saying, "Yes, I am feeling that way!" Keep going and nurture these virtues.

- **curiosity** - the desire to learn or know more about something or someone
- **initiative** - the energy and desire that is needed to do something
- **commitment** - the attitude of someone who works very hard to do or support something

Curiosity

The elemental artist is all about searching, learning, and seeking in a quest for knowledge of art and life. Curiosity is the essence of being an artist.

Initiative

The elemental artist has started learning art through local classes or online learning. You are learning the language of art, vocabulary and concepts about paints, brushes, painting surfaces, mediums, and processes.

Commitment

You have committed time, effort, and resources, no matter how little or great, to becoming an artist. The elemental artist practices with the intention of learning, not making masterpieces. Think of your efforts as exercises to help you get to the next level.

Watch Out for Overworking

The elemental artist is in a learning phase, but you may have a natural tendency to want to get it right and to continue working on a painting until "it's right." This mindset can result in an overworked painting where all the fresh, painterly marks have been overblended or overdabbled. Overworking is the opposite of a "fresh" painting.

The Elemental Artist's Growth Plan

Learn the elements of art.

This stage is all about preparation and developing a solid foundation of technical skills that you can build on and grow from. Learn the elements of art—line, shape, value, color, space, texture, and form.

These are basic concepts that naturally guide the artistic process. Painters, sculptors, photographers, and all creators use them. Study the principles of each and learn how to apply them to your art. They are key.

Incorporate what you are learning about art into your everyday life.

See line, shape, color, value, space, texture, and form all around you. Notice the shifting colors, shadows, and light in nature at various times of the day: morning, midday, and late afternoon. Art is very much about seeing—and not just while you're painting. Seeing through your artist's eyes in your everyday life will help you to see more clearly when painting.

Practice, practice, practice.

This is what every teacher I've ever studied with has said in different ways.

> "Paint miles of canvas."
> "Paint ten thousand hours."
> "Paint a hundred starts."

Don't worry about developing a personal style. Get your skills down, and your style will show up in the process.

Learn how to use tools that will help you see like an artist.

Sometimes in the middle of painting we look at our work in progress and feel stuck. Something is not right, but what is it? Errors in drawing or value seem to pop out more easily when seen through a different portal. For example, take a photo of your artwork with your phone, and look at it in black and white. Or hold a mirror up to your painting in progress to give you a different point of view.

Experiment with different types of art and supplies.

Realism, impressionism, expressionism, abstraction, pop art. Watercolor, acrylic, oil paint, gouache, mixed media, glass, resin, paper, pastels, pen and ink, digital. What takes your fancy? Try them all and go on to master a few.

Do many painting starts.

Starting new paintings is more important than meandering around the same painting for weeks, overworking all the beautiful freshness you started out with.

Read art history.

There is great inspiration in art history. Here are just a few prompts to get you started.

- What were the interests and inventions of Leonardo da Vinci?
- How was the *Mona Lisa* stolen from the Louvre?
- After World War II, what national program in the United States employed artists to paint murals for public buildings?
- What medium did Matisse switch to when he became too ill to paint?

 For more food for thought, search *interesting facts about famous paintings (artists)* online.

There are also fabulous art history podcasts like Art Curious which present art history like an intriguing tale of mystery.

Read a painting instruction book.

When I read a good art instruction book, I make sure I have my highlighter. I love to mark through all the things I am inspired by and want to remember. I could easily go back and reread the highlighted areas of the book down the road to remember my favorite parts, but I take it one step further. When I'm done reading the entire book I go back and type out all my highlighted words in one document and save it on my Trello board of notes. Sometimes I even categorize highlighted notes under categories like "Line", "Shape", "Color", etc.

Other ideas:
- Use the Notes app on your phone to jot notes while listening to the audio version of an art book
- Handwrite your notes in a beautiful journal
- Make a voice recording on your phone that you could play back to remember the book notes in your own words

Start to think about your pre-painting process.

How and where do you find inspiration? What time of day are you most alert and most full of creativity? Is your paint time marked on your calendar? Habits and routines can make your pre-painting process a natural prelude to your art.

Contribute to an art community locally or online.

Join your local arts alliance. Do an online search for *(your town) arts alliance* and this will bring up agencies that support the arts in your area. They offer classes, workshops, competitions, and opportunities for showing your work when you are ready. My local arts alliance was crucial in my transition to a professional artist. I met other local artists and bonded in our goal of sharing our creations and just how to do that logistically. I learned valuable business knowledge that I needed to grow in my business. My local arts alliance offered my first opportunity to show my work in a gallery through their co-op gallery. I am forever grateful for their help.

Another great option for a supportive art community is joining an online art community. Many artists host their own group so if you love a

particular artist, they may have a group you can join. I do. There are also general groups for *acrylic artists, watercolor artists,* etc., that you can search and join on your preferred social networking site.

Have your supplies ready to go.

It's easy to jump in and dabble whenever you have a moment if your materials are handy. Keep them arranged on a table in a spare room or stored together in one box ready to grab quickly. Whatever your workspace, just make sure you've got everything you need in one place.

Work on your art when you are alert and energetic.

Strike while the iron's hot! Stop when you start to feel tired or lose inspiration. If you suddenly find yourself putting down brushstrokes and don't know why, it's a sign to stop. I find this is when I make mistakes.

Practice reviewing your own art after you finish a piece.

Take off your painter's hat and put on your art critic's hat. Does the piece feel right in form and composition? Are the colors as bold or as muted as you would like them to be? Does the finished piece convey your original intention? For example, your intention may have been to capture the way the light was falling on the beach at daybreak. Did you accomplish this? There are a million intentions, and all are correct.

Be gentle on yourself.

Gratitude can help us overcome the tendency to be disappointed in a creative outcome or compare ourselves to others in this stage. Be thankful for the things you already have learned. Those things are helping you critique your artwork and learn from mistakes so that you can move on to the next piece and start the process again with a little more knowledge and confidence. Enjoy the process and be thankful for the time you have given yourself to practice.

The heart of an Elemental Artist

1. The elemental artist has made a commitment to learning the basic elements of art.
2. You are curious about different mediums.
3. You are eager to try new things in this exploratory period.
4. You are starting to have a feel for the type of work you want to create.
5. You wish you had more time to paint, but you feel good about starting.

Chapter 4

The Seeing Artist

The seeing artist's symbol: the
out-reached branch

*Vision is the art of seeing what is
invisible to others.*
Jonathan Swift

Branches find the shortest route to the sunlight—
and are even able to bend in the direction of the
light source.

The seeing artist is well on their way to seeing
the artistic path through the clutter.

The Seeing Artist's Virtues

Here are some virtues of a seeing artist. You may find yourself saying, "Yes, I am feeling that way!" Keep going and nurture these virtues.

- **awareness** - state of showing realization, perception, or knowledge
- **diligence** - steady, earnest, and energetic effort; devoted and painstaking work and application to accomplish an undertaking
- **appreciation** - awareness or understanding of something
- **wonder** - a feeling caused by experiencing something that is very surprising, beautiful, or amazing

Awareness

This is an exciting stage! You have learned many skills and techniques of painting as an elemental artist, and now you have transitioned to a higher state as a seeing artist. You see lines in the houses on your street, value shapes in the shadows and light on trees, colors of various greens of your garden, texture in the smooth petals of a rose, space in

the shapes between the clouds, and how all these elements create form all around us.

Diligence

Through a careful and persistent work ethic, the seeing artist has gained knowledge and understanding of their craft and has awoken to the power of seeing the world differently. This new insight and vitality has given you the confidence to say, "I am an artist." You feel like an artist because you can see like an artist.

Appreciation

You have mastered left-brain knowledge and skills and now are ready to transform your artwork with the ease this vision has given you. When you were an aspiring artist, you saw each subject as its name. Now you see and appreciate them as the lines, shapes, colors, values, spaces, textures, and forms that make them up. The magic of this stage is that by not painting "a sunflower" but by painting its lines, value shapes, colors, and texture, you actually paint a sunflower.

Wonder

It is thrilling to see so differently now. You observe the world through the lens of your art vocabulary (line, shape, color, value, space, texture, form). Wonder makes every moment a learning moment, training you for the time when you use this knowledge to paint and create.

Watch Out for Doubt

It's normal at this stage to say, "Is it really this simple?" It is much harder to see than it is to render. You have accomplished the harder part of seeing like an artist, and that makes painting much easier. Trust yourself and your process.

The Seeing Artist's Growth Plan

Convey your unique vision onto the canvas.

Combine the technical skills you learned as an elemental artist with the power of seeing like an artist to convey your unique vision and intention onto the canvas.

Observation precedes intuition.

Remind yourself to have fun using your artist's eyes throughout the day: looking, thinking, observing, preparing.

Become more aware of your other senses.

Stop and smell the roses. By expanding the power of sight and becoming more fully aware of other senses, we become more present and mindful in each moment, increasing the chance of remembering special moments of inspiration. Imagine this: you are at the beach, feeling the warm sun and sand between your toes, hearing the power of the waves rolling in and out, seeing the beauty of the colors in the water, smelling the salt in the air, and tasting the salt on your skin. These are all powerful cues that help you remember the beach when the time comes to interpret it on the canvas.

Perfect your painting process.

Perfecting a painting process allows you to get in the painting groove more easily. This can also be especially helpful when you take time away from

your painting and then try to get back into it. Just gently start from the beginning of your process or routine and ease back into it, assured that through your unique process, creativity and inspiration will show up.

Now look for teachers who are skilled in teaching the specific areas where you need improvement.

At this point in your journey, you will know what you need to work on. Is it perfecting bold, beautiful color, or capturing light more effectively in your work? Whatever you feel you need, seek out an artist who does it well and learn from them.

Sell your art!

Whether you post your artwork on social media or run into someone at the grocery store who says, "What have you been up to?" you will get inquiries about your artwork. It's best to have a simple website where you can send potential collectors who can learn more about you and possibly purchase your art. Websites like FASO.com are designed for artists to create their own branded website with virtually no techy experience. Another option is dailypaintworks.

com where you can simply post your latest piece for sale amongst other artists. I've used both these options in the past and when I was ready, I took it a step further to create my own website.

A local art co-op is also a great way to ease into gallery sales. That's how I got my start. I applied to be in the local co-op gallery run by my local art alliance, was accepted and then worked a certain number of hours/month in the gallery. It was so interesting to talk to the people that came in. I found out what they were drawn to and looking for in art. It was where I first learned that people just don't buy a pretty picture because it's pretty. It's a deeply emotional experience when someone is drawn to a painting due to past experience with a loved one, favorite place, or thing.

Teach what you know about art.

Teaching will reinforce and grow your knowledge and understanding of your craft.

There are many opportunities for sharing your love of art with the world. How about volunteering to teach at a children's art camp, senior living, or correctional facility? If I lived in a big city, I would love

to be a museum docent helping visitors understand the process and artist behind the paintings.

I shared my interest in art as art volunteer at my local elementary school for many years before I became an elementary school art teacher and started painting professionally. Now I teach adults in person and online. It has made me a much stronger artist. I love to research new ways to help my students learn and through the process, continually find new insights that expand my artwork as well.

Visit museums ... again.

See the famous artwork more completely with your new knowledge of the elements of art. You have learned enough to see how the artist used the elements throughout the painting and why they chose a certain color palette, or possibly even to figure out the artist's intention.

Enjoy this wonderfully fulfilling stage and think about how far you've come.

The heart of the Seeing Artist

1. You see the elements of art all around you in everyday life.

2. The elements are helping you create a painting process.
3. These elements give you confidence to go from inspiration to painting fruition.
4. Now it's easier to recognize how the elements are helping you while you are creating.
5. Your artistic life is exciting, energizing, and full of wonder.

Chapter 5

The Intuitive Artist

The intuitive artist's symbol:
the well-established tree

The tree ... is the medium through which the idea of the wind is expressed.
Robert Henri

The intuitive artist has become disciplined in the elements to the point where you can now respond to your own impulses and enjoy a sense of individuality and style in your work that was not possible in earlier phases. You are a unique vehicle through which beautiful ideas are expressed.

The Intuitive Artist's Virtues

Here are some virtues of an intuitive artist. You may find yourself saying, "Yes, I am feeling that way!" Keep going and nurture these virtues.

- **confidence** – feeling or belief that you can do something well or succeed at something
- **stamina** – the capacity to sustain a prolonged activity
- **intention** – a determination to act in a certain way; resolve
- **optimism** – anticipation of the best possible outcome
- **flexibility** – a willingness to change or to try different things
- **patience** – giving of attention to something for a long time
- **decisiveness** – decision making that is quick and effective
- **gratitude** – a feeling of appreciation or thankfulness
- **intuition** – quick and ready insight

Confidence

The intuitive artist has found the artist within while continuing to evolve and mature. Learning still feels new and invigorating. Confidence helps you to work decisively, without fear of ruining a painting. To an outsider, the intuitive artist makes painting look easy, even though it isn't.

Stamina

It isn't easy being an artist, but the intuitive artist has persisted and learned something rare—something that is perhaps not known to most people. Intuition has come from self-discipline, persistent effort over time spent looking, seeing, thinking, and practicing.

Intention

In addition to conquering the technical skills and artists' sight, the intuitive artist now responds to emotional impulses—you bring more of yourself to your work. Technical skills allow you to convey how you feel and to express your message through your

work. The spark that inspired you to paint a subject is evident. Your style is showing.

Optimism

The intuitive artist sees painting mistakes as the opportunity to create something new.

Flexibility

The intuitive artist is willing to change course when painting is not going as planned and to try a different approach.

Patience

We saw patience on the list of virtues for the aspiring artist when you were just starting out. You needed patience for the journey ahead. It can't be rushed. It simply must be practiced. The intuitive artist is one who has become patient with their process. You trust each step and are not put off by things like a seemingly disorganized artwork in progress. You are not rushed to finish one part of a painting before the rest. Patience helps you know

that your process will get you where you want to go in the end.

Decisiveness

The intuitive artist responds to a painting as it evolves. You can *feel* when something is right or is wrong. The painting tells you what it needs.

Gratitude

The intuitive artist sees with an artist's eyes and feels with an artist's heart. You are more in tune with nature and receptive to the inputs of your senses. You possess an appreciation for the gifts acquired and feel a generosity about sharing them with others.

Intuition

The intuitive artist has immediate access to the knowledge they've learned without thought. Intuition can show up as easily as knowing which colors to mix together to create the desired result.

Watch Out for Stagnation

Evolving requires contemplation. Life is ever-changing and, as artists, so are we. It's easy to get stuck in a methodical rut, doing the same thing over and over. Your art will change over time if you continue searching and learning. Personal growth in all areas of your life will inspire new ways to use all that you already know about art. The evolving nature of artists is evident when you view the artwork of a master painter over the course of a lifetime. Your style naturally evolves as you do. Change is OK.

The Intuitive Artist's Growth Plan

Be a lifelong learner.

Be a lifelong learner about many different things. Insights into gardening, cooking, philosophy, business, and other pursuits will enrich your art.

Cultivate and continue to trust your intuition.

It knows the way.

Share more.

It is through teaching that we learn and grow.

Cultivate more of a flow state.

You can turn off your critical left brain in many ways, such as listening to audiobooks or music while painting.

Reread your favorite art books.

You will find yourself in them.

Continue to study the basic elements of art.

The elements of art can be studied infinitely. Artists are meant to keep going back to the basics you first learned about in the elemental artist phase.

At this point in your path, you may find that you interpret the elements in new ways, expanding their original meaning. Dive deeper and allow them to expand your creative potential. In this way the path of an artist becomes a complete circle. There is no end to learning and growing. The elements will continually guide and inspire us.

The heart of the Intuitive Artist

1. The intuitive artist has developed a quick and ready insight.
2. You see the end result in your head.
3. The artwork is created seemingly effortlessly and decisively, with a wisdom that is not conscious.
4. You have direction but respond to the evolving painting with flexibility.
5. Each step feels right, consciously or subconsciously guided by the elements of art.
6. You are intensely focused on and absorbed within the unfolding creation.
7. You are joyfully process-driven.
8. The resulting painting is a bonus.
9. Time stops.
10. You feel excited, energized, and full of zeal and wonder.
11. Life is good.

Chapter 6

Personifying the Virtues

Successful artists haven't just been born with special magic abilities. Sure, some people have a propensity towards art. But it's the artist who practices good skills and demonstrates good virtues who is blessed by an enriched creative life.

And there *is* magic when everything you've studied and practiced flows through you and comes out on the canvas without thought. This state of mind is often called "being in the zone" or "experiencing timelessness." It is also represented in Csikszentmihalyi's explanation of flow, Maslow's theory of peak experience, or Aristotle's idea of eudaimonia. It is not a continuous state but rather moments in time that cannot be forced, only nurtured through good practices.

I know that I am in this state when the painting seems literally to flow right out of me onto the canvas. Short periods like this can happen at any point in your art journey, but they are more likely to happen after you've learned the basics as an elemental artist, gained awareness as a seeing artist, and grown more confident as an intuitive artist.

It is advisable then to focus on the process. It is through the process of learning, practicing, and creating that you become an artist. And while there are rhythms and seasons, and ebbs and flows in a creative life, if we are confident in our skills and processes, we can be confident they will always remain with us.

As you personify the artist's virtues, you become an artist *and* your best self.

The quest for this more-than-ordinary state of existence can bring:

personal growth by learning, growing, and working at your craft

relaxation by thinking and doing something totally different from day-to-day life

calm from the storm

peace of mind

the **pleasure** of dipping your paintbrush into ooey-gooey paint and making marks on the canvas

the **joy** of creating

the **fulfillment** of making something you (and others) love

the **excitement** of discovery

the **self-discovery** of what you can *do*

the **self-expression** of what you can *make*

the **self-satisfaction** of being able to say, "I made that"

the **happiness** of making something beautiful

confidence in yourself and your painting process

the **love** of making and giving

an **escape** from the usual routine

the **fun** of playing

the **challenge** of learning something new

the **beauty** of creation

freedom and flow of expression

a feeling of **inspiration**

the **wonder** of the natural world

the **rewards** of selling, showing, or teaching your craft

Once you determine that art is a worthwhile endeavor for you, pursuing the virtues of an artist is a recipe for happiness.

It takes courage to push yourself to places you have never been before ... to test your limits ... to break through barriers.

And the day came when the risk it took to stay tight inside the bud was more painful than the risk it took to blossom.
(often attributed to Anaïs Nin)

Glossary of the artist's virtues

appreciation: full awareness or understanding of something

awareness: the state of showing realization, perception, or knowledge

commitment: the attitude of someone who works very hard to do or support something

confidence: a feeling or belief that you can do something well or succeed at something

courage: the ability to do something that you know is difficult

curiosity: the desire to learn or know more about something or someone

decisiveness: quick and effective decision making

diligence: steady, earnest, and energetic effort; devoted and painstaking work and application to accomplish an undertaking

enthusiasm: a strong excitement about something; a strong feeling of active interest in something that you like or enjoy

flexibility: a willingness to change or to try different things

gratitude: a feeling of appreciation or thankfulness

harmony: a pleasing combination or arrangement of different things

initiative: the energy and desire that is needed to do something

intention: a determination to act in a certain way; resolve

intuition: quick and ready insight

optimism: anticipation of the best possible outcome

patience: the ability to give attention to something for a long time without becoming bored or losing interest

stamina: the moral or emotional strength to continue with a difficult process or effort; the capacity to sustain a prolonged effort or activity even if stressful

wonder: a feeling caused by experiencing something that is very surprising, beautiful, or amazing

zeal: a strong feeling of interest and enthusiasm that makes someone very eager or determined to do something

Printed in the United States
by Baker & Taylor Publisher Services